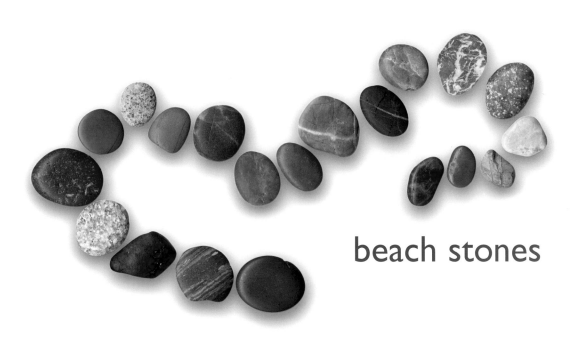

beach stones

abrams, *new york*

beach stones

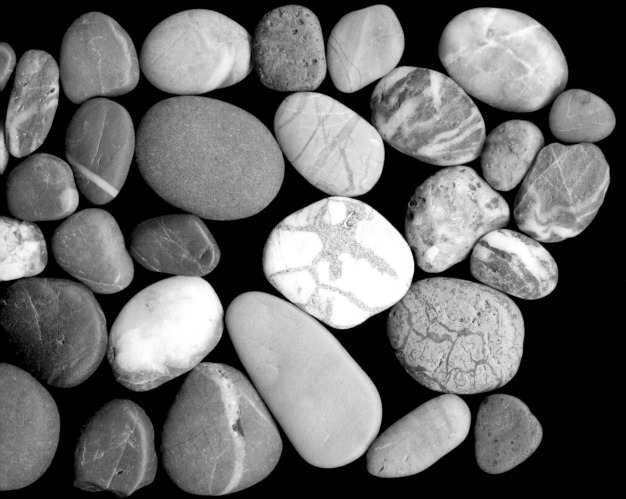

photographs by josie iselin | text by margaret w. carruthers

Editor: Nancy E. Cohen
Designer: Darilyn Lowe Carnes
Production Manager: Jane Searle

Library of Congress Cataloging-in-Publication Data

Iselin, Josie.
 Beach stones / by Josie Iselin and Margaret W. Carruthers.
 p. cm.
 ISBN 0–8109–5533–4 (hardcover : alk. paper)
 1. Photography of rocks. 2. Iselin, Josie. I. Carruthers, Margaret W.
II. Title.

 TR732.I84 2006
 779'.3092— dc22 2005028520

Printed and bound in Singapore
10 9 8 7 6 5

HNA
harry n. abrams, inc.
a subsidiary of La Martinière Groupe

115 West 18th Street,
New York, NY 10011
www.hnabooks.com

for Ken | JLI

for Abigail | MWC

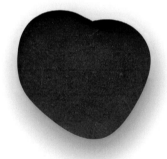

Pescadero, California

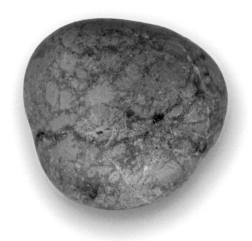

San Francisco, California

introduction

What compels us to walk along the beach, our gaze fixed upon the sand? We can't resist the smooth, surf-polished stones that have been tossed this way and that by the waves. Their intriguingly varied colors, patterns, and shapes draw us to the hunt, and soon our hands and pockets are full. Something about beach stones is comforting. They don't age, die, or fade away. We perceive them as paragons of permanence and immutability.

But in fact the timelessness of stones is merely an illusion born of our own fleeting presence on Earth. Their features are a testament to impermanence, a witness to change. Every spot, stripe, fault, and fold that tempts us to pick up a pebble holds a fragment of Earth's four-and-a-half-billion-year history.

A beach is a strip of loose material at the water's edge, a collection of sand and stones assembled, disassembled, and reassembled by the sea. On the geologic time scale, it is ephemeral. And for most stones, the beach is just the latest stop on a journey that began eons ago.

After witnessing a furious storm rearrange an entire coastline or listening to the chatter of the pebbles as they tumble against each other, picked up by one wave and deposited a few feet along the shore by the next, we might

assume that beach stones are carried up from the deep sea by the waves and tides. In fact, most beach stones don't come directly from the sea but are washed from the land, having traveled tortuous routes to reach it. Many were buoyed up from the depths of the Earth or rode on the backs of the great tectonic plates, then were thrust skyward to form the mountains. Rivers, glaciers, and sheer gravity carry them down to the sea from distant heights, while friable cliffs surrender a daily supply of sediment.

A rock does not become a stone until it has been freed from the bedrock, its sharp edges rounded off and rough texture smoothed—fashioning that generally occurs at or on the way to the beach. The rough rocks that become beach stones themselves arise in three ways. Igneous rocks, such as granite and basalt, solidify from molten rock—lava above the Earth's surface or magma below. Sedimentary rocks form when particles of sediment coalesce, as, for example, when pieces of broken rock become sandstone and crystallized minerals combine into limestone. Metamorphic rocks, such as gneiss and marble, form when other rocks are squeezed or heated until their components rearrange themselves to form new minerals, new textures, and entirely new rock.

The rock's cycle does not end with the stone that sits so comfortably in the hand. The beach stone itself is now a sediment, on its way to becoming part of a sedimentary rock. By one route or another, it is likely to be buried, metamorphosed, and melted to begin anew.

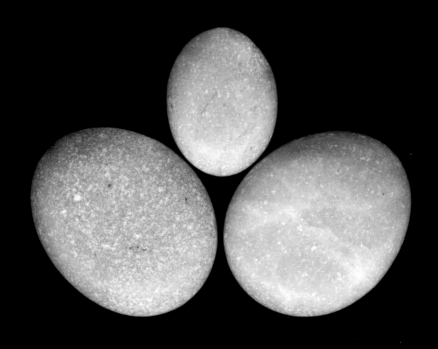

Koh Chang, Thailand

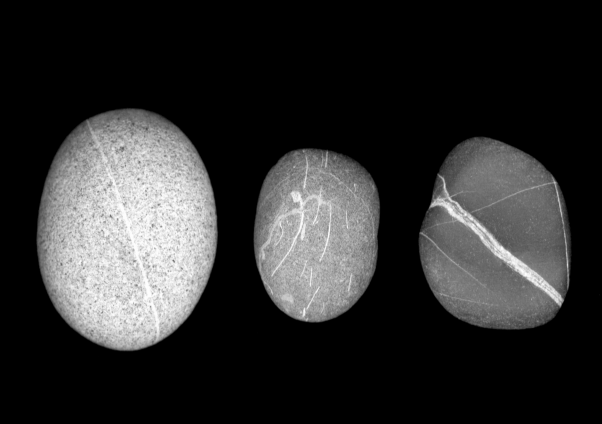

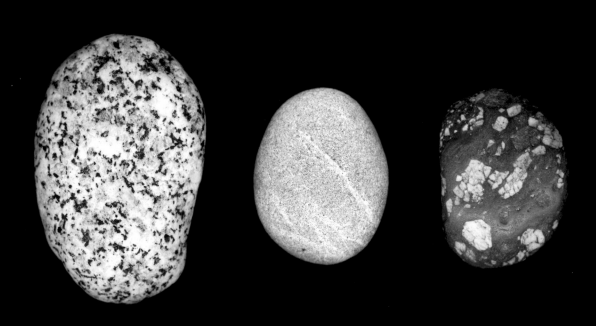

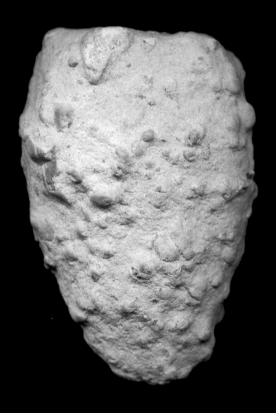

Cape Cod Massachusetts

Resembling the fossilized warts of an ancient amphibian, the greenish knobs on this sandstone are rounded grains of feldspar that were exposed by the erosion of the stone's looser, finer-grained, and less resistant sand.

13

The gray rock's incomplete icing of white is a partially eroded vein of quartz. Left to roll in the surf for a few more centuries, the quartz vein would have been obliterated, chiseled off by other rocks to form tiny grains of sand and grinding other stones to sand in the process.

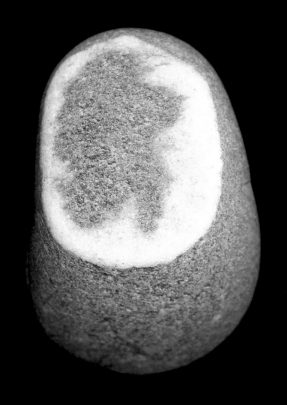

San Francisco, California

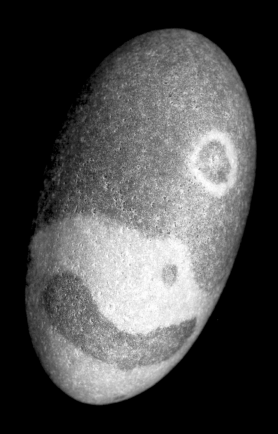

Devon, England

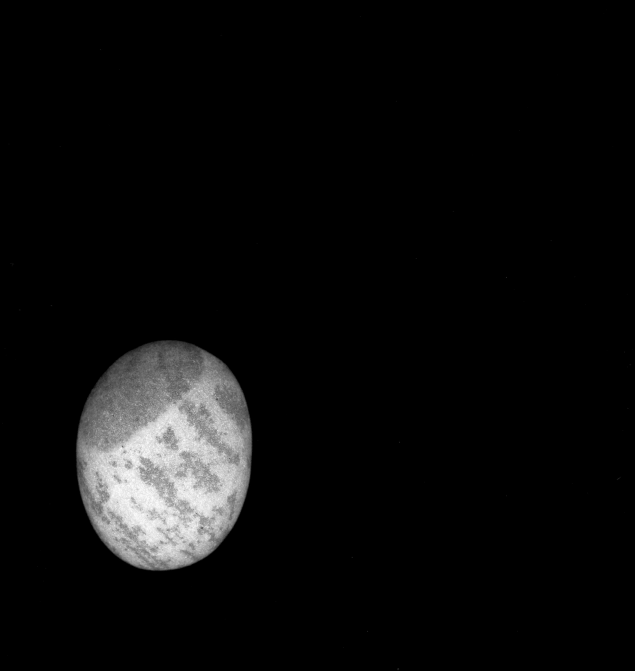

preceding pages: This petrified sock monkey, found lolling in the surf on the southern coast of England, is a rare find. Its unique features are painted in iron oxides acquired, perhaps, during its sojourn in a continental desert long ago. Although such details appear literally set in stone, they are evanescent. Had it been left in the surf, tumbling among other beach pebbles and abraded by the sand and grit carried by the waves, the sock monkey would soon have worn a somewhat different expression—and perhaps resembled a child's toy no more.

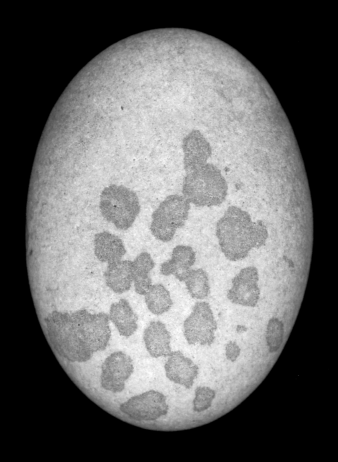

Devon, England

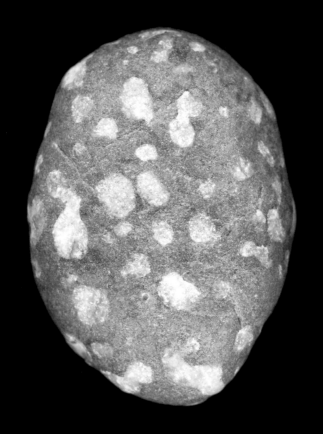

North Haven, Maine

Two separate processes conspired to form this basalt stone. Basalt is a volcanic rock that begins as magma, a slushy mixture of liquid, mineral crystals, and gas. As magma rises from deep beneath Earth's crust toward the surface, the gas bubbles out, leaving behind holes in the lava as it cools and solidifies. Then, ever so slowly, groundwater percolating through dissolves elements from parts of the rock and deposits them in the holes, giving rise to the distinctive crystalline dots seen here.

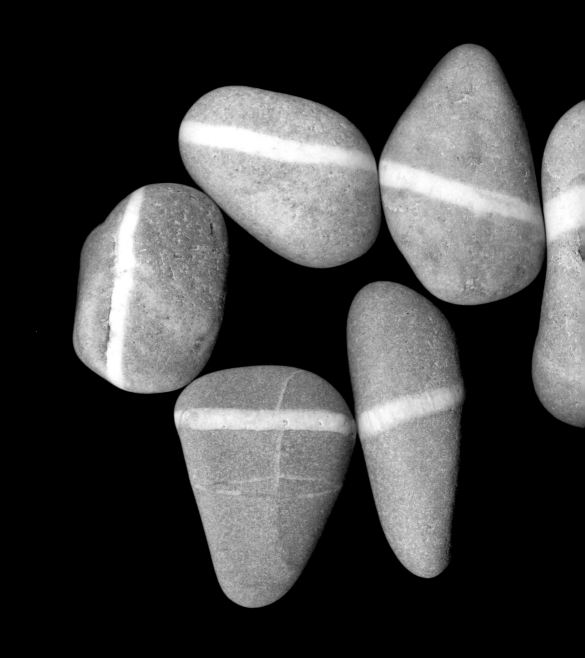

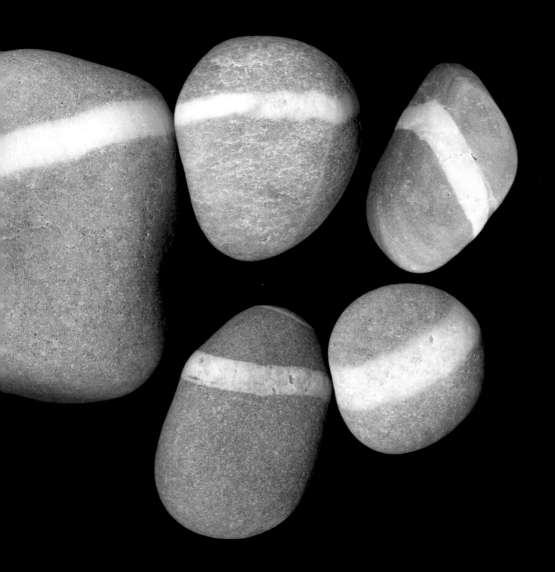

North Haven, Maine

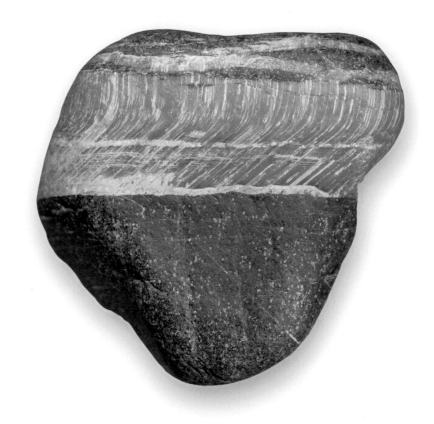

Orick, California

This stone was found on the cool and foggy northern coast of California. The black basalt rock, originally part of the Pacific's crust, was folded and fractured during a tectonic collision 150 million years ago. Hot fluids flushed the cracks, filling them with a green, fibrous, relatively soft mineral called antigorite, which formed the shimmering seam.

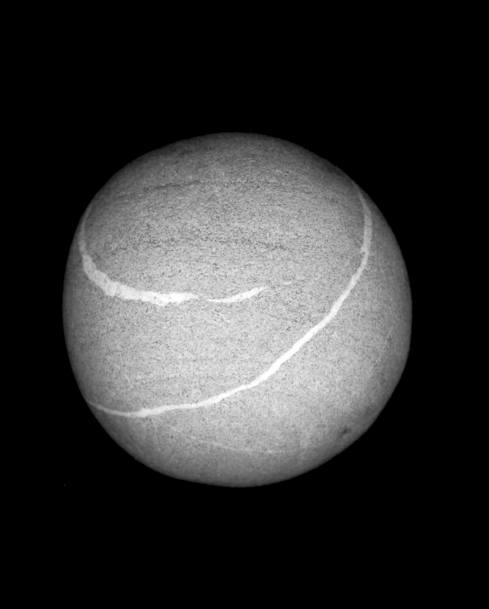

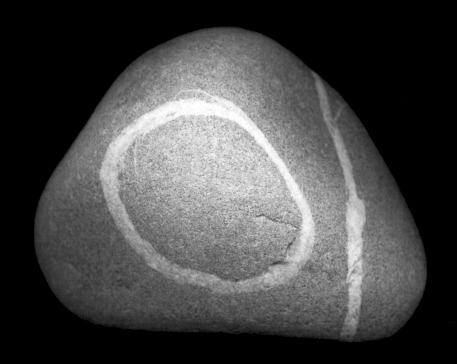

Hopland, California

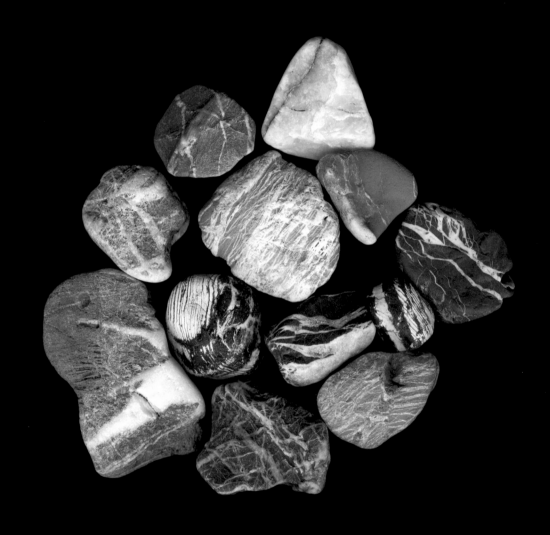

Stinson Beach, California

When the tide is right, a beautiful array of pebbles sits at the waterline of an otherwise sandy beach. How sandy or gravelly a stretch of beach may be—a condition that can change from year to year, season to season, day to day, and hour to hour—is determined by the play of gravity, wind, and water, which collaborate to sort rocks by size. Where (or when) the water is relatively calm, sand is deposited; when wave energy is high, sand is carried away, leaving larger stones behind.

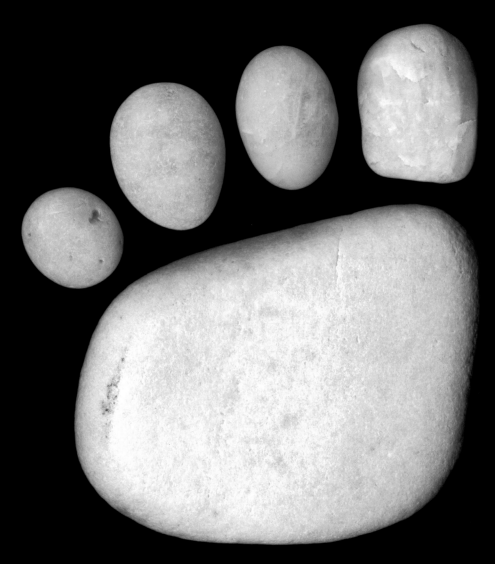

Evvoia, Greece

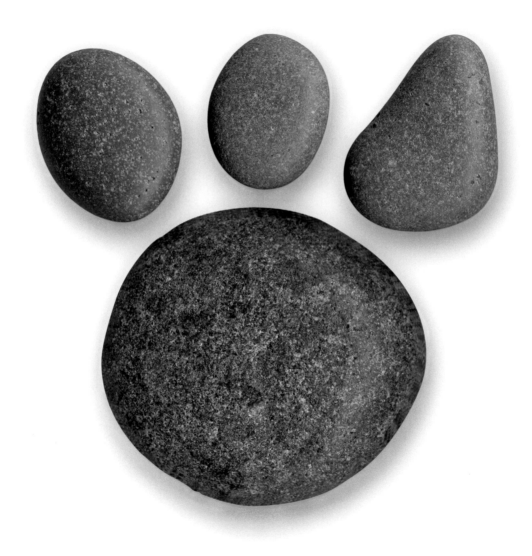

Chios, Greece

The Acadian Mountains, now long worn away, formed roughly 400 million years ago along the eastern edge of what was to become North America. Their remnants are rocks like this one found on an island in Maine's Penobscot Bay. Originating as sand and mud on the floor of an ancient ocean, it was gradually transformed into rock by the pressure of layer upon layer of sediment. The ocean's closure violently thrust the sea floor onto the continent, metamorphosing, folding, and fracturing the rock and allowing calcite to fill the breaks and form the white veins running through it.

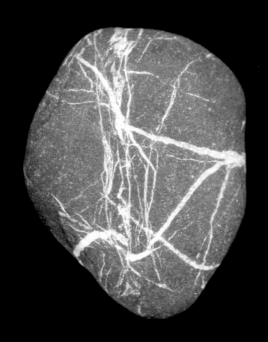

North Haven, Maine

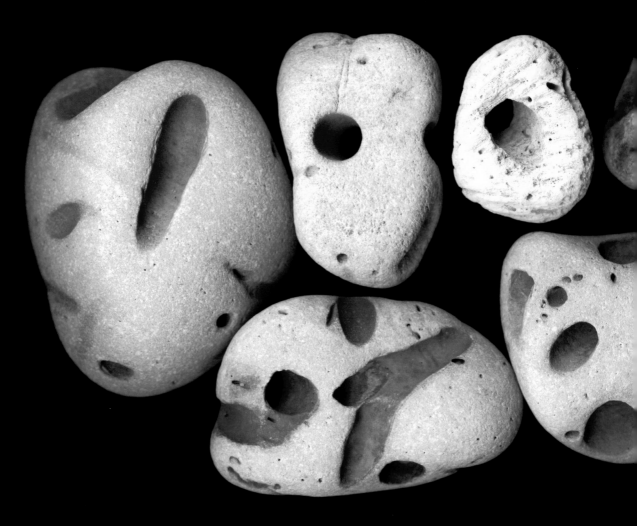

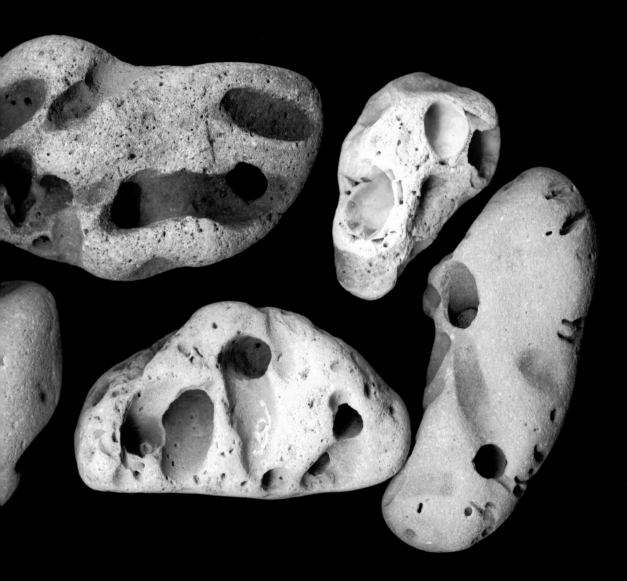

Santa Clara, Brazil

preceding pages: The holes in these stones are fossilized burrows, perhaps of a worm or shrimp. Ichnologists, who study trace fossils such as burrows, tracks, and borings, consider them fossilized behavior, snapshots of the lifestyle of some ancient organism.

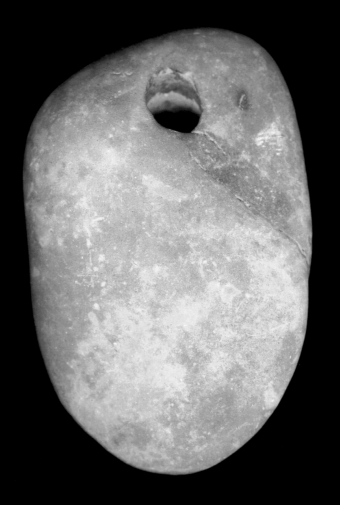

Bolinas, California

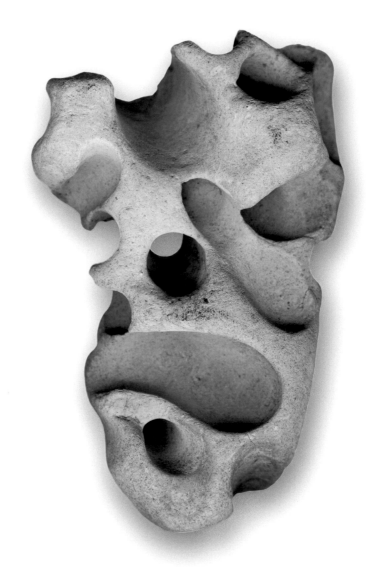

Bolinas, California

The agents of erosion responsible for breaking down rocks include wind, waves, fluctuating temperatures, gravity, and even homeless clams—the source of the holes in the stone here.

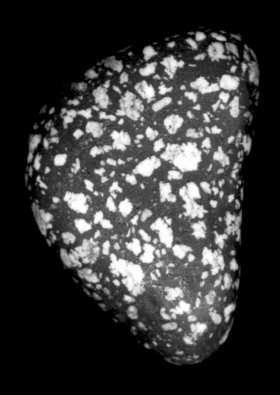

San Francisco, California

Most igneous crystals large enough to see with the naked eye form deep within the Earth. They must wait millions of years for wind, rain, living organisms, and gravity to erode the rocks above and expose them. The white feldspar crystals in this rock found a quicker way to the surface: The magma that had lingered at depth, allowing the crystals to form slowly, erupted. The rest of the mixture quickly solidified into the microscopic crystals that appear as the feldspar's dark background.

The coiled backbone of this pebble is the 200-million-year-old shell of an ammonite, a squidlike creature that swam in the tropical Jurassic sea that is now England's southwest coast.

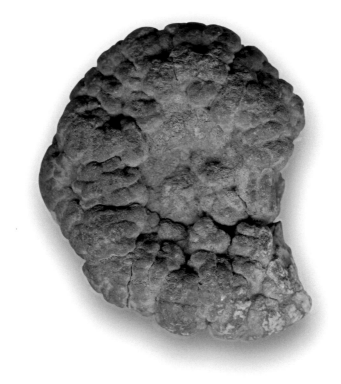

Dorset, England

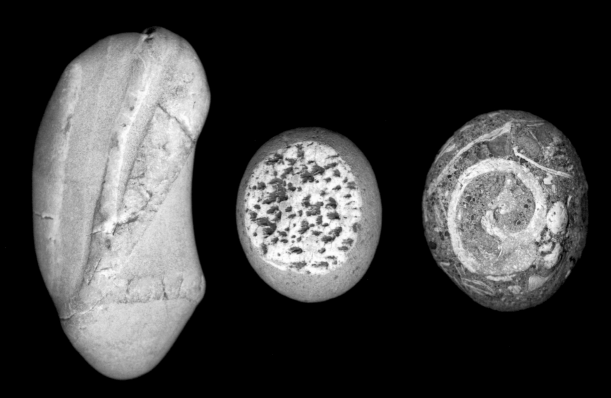

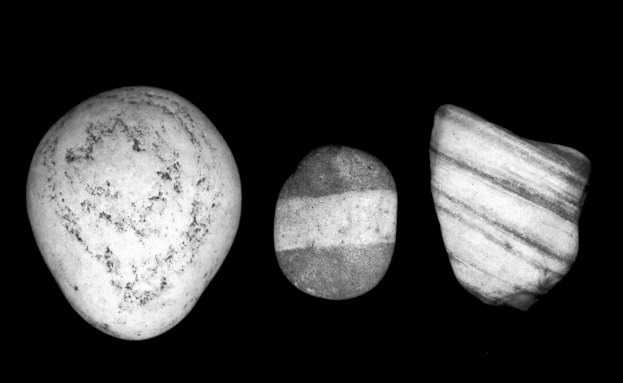

After slowly solidifying miles beneath the Earth's surface, granite must wait millions of years for ice and running water to wash away the confining layers above and expose it. Enormous masses of Maine granite, 400 million years old, have yielded innumerable cobblestones and were used to clad the great civic and religious buildings of Washington, New York, and Philadelphia.

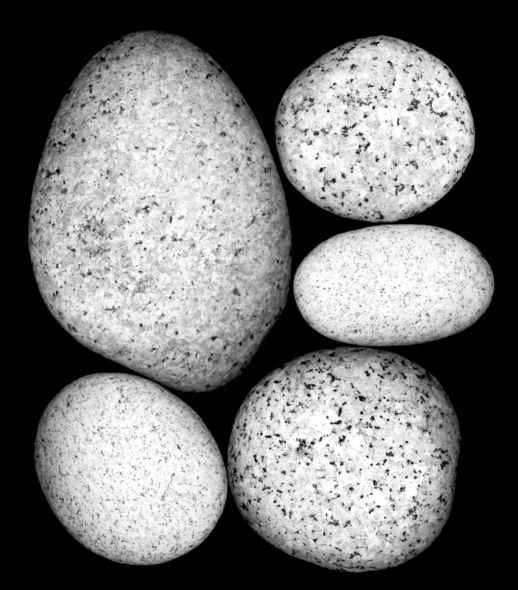

Hurricane Island, Maine

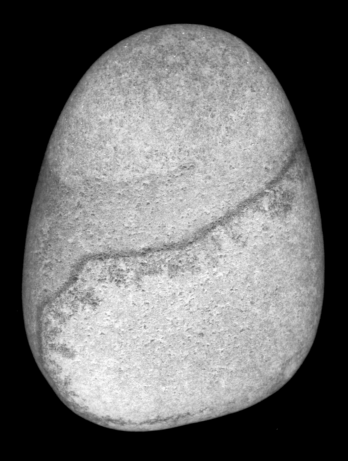

Devon, England

This 440-million-year-old quartzite pebble is lightly stained by iron oxide minerals, tiny crystals trapped between grains of quartz. The yellow and brown come from limonite and goethite, the red and purple from hematite—the same minerals that form rust on iron fences and railings. A metamorphic rock, quartzite was once a sandstone. The sandstone itself was once a pile of quartz grains on a beach or in a desert.

This stone appears to be composed of disparate materials, but both the white seam and the gray rock itself are made largely of quartz, one of the most common minerals in the Earth's crust. The enormous pressure that transformed what was once muddy sandstone into quartzite also ruptured it in places. Scalding water rushed into the cracks, eventually mending them with the quartz dissolved in it.

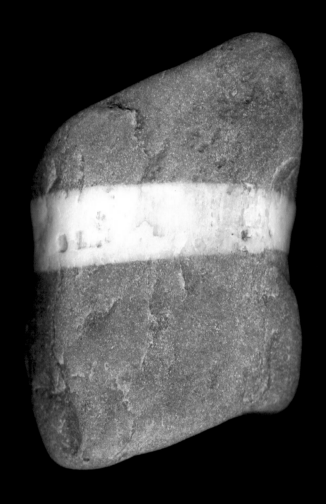

Vinalhaven, Maine

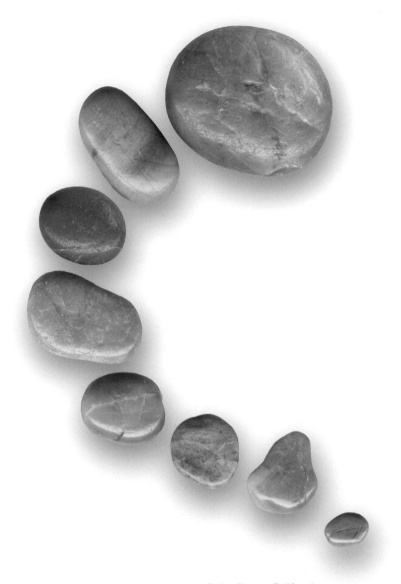

Point Reyes, California

Color is many stones' most striking aspect, but it is an unreliable way to identify a mineral. Quartz, for example, is clear and icy when pure, milky when filled with tiny bubbles of air or fluid. Titanium atoms can tint it pink, while embedded needles of titanium oxide can make it blue. It can be yellow, orange, or purple with iron; smoky with aluminum; and green with green mica. These green pebbles are chert, a dense mass of microscopic quartz crystals that easily can be mistaken for jade.

What sculpted this stony fish? Certainly water took part in the rounding and smoothing, aided by sand, grit, and other stones. Perhaps a modern-day clam bored through to make a home of the eye, mouth, and gills. Or maybe the fish features formed millions of years ago, when some sea creature excavated a dwelling in the loose sediment that would become this rock.

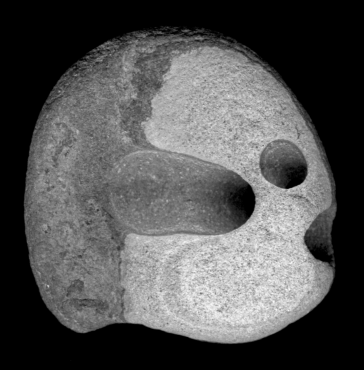

Newport Beach, California

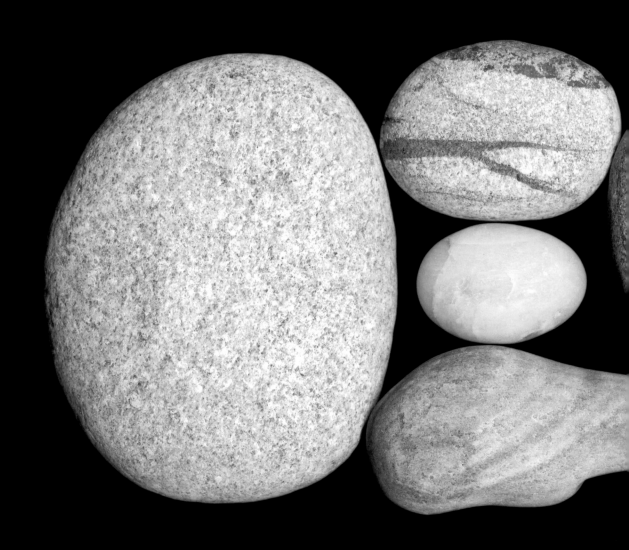

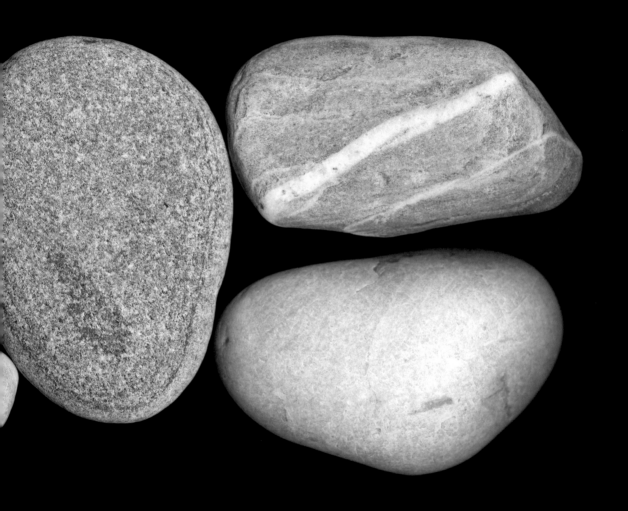

Evvoia, Greece

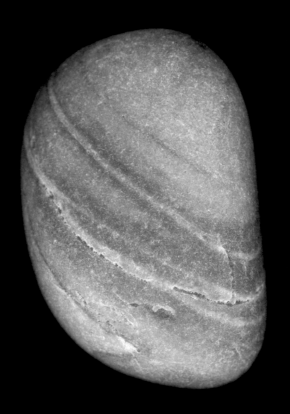

Devon, England

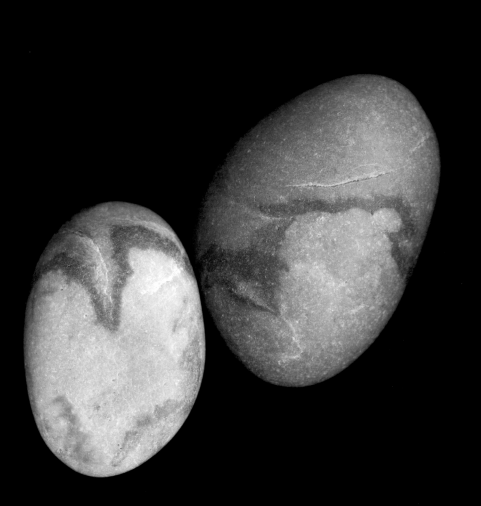

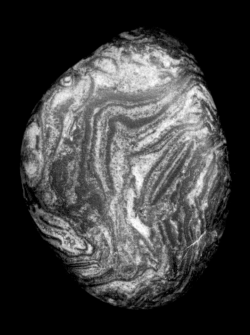

Stonington, Connecticut

The swirling layers in this gneiss pebble look as though they formed when two liquids, barely mixed, were left to harden. In fact, they took shape while the rock was completely solid. Gneiss is a metamorphic rock that forms deep in the Earth's crust after the application, over millions of years, of extremely high pressure and temperature. Its elements rearrange to form new crystals, and without ever liquefying, the rock flows slowly, twisting the layers within.

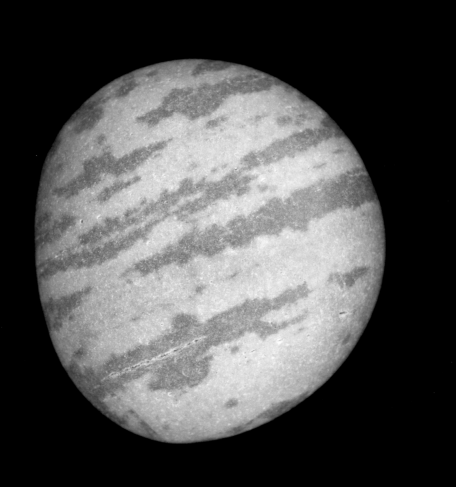

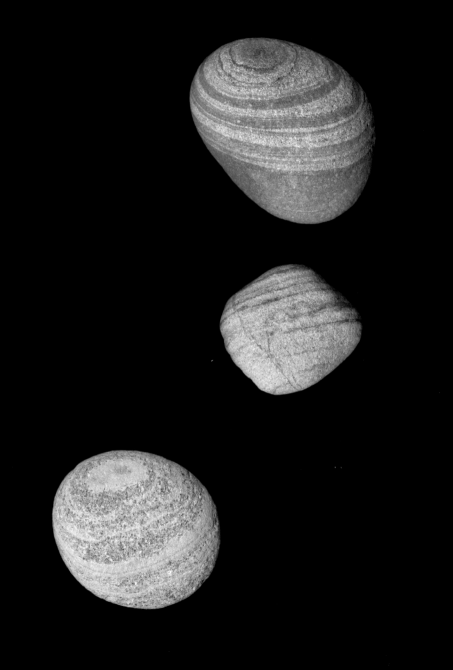

preceding pages: The bands that compose these tiny planets reflect the subtle rhythms of the seas, rivers, and winds that lay sediments down. Over time, the sediments build up into layers, each made of slightly different minerals or grains of slightly different sizes and shapes and therefore distinct. Each is a record of the event that initially deposited the sediment: perhaps a springtime snowmelt, the passing of a storm, or the slow migration of a river across the landscape.

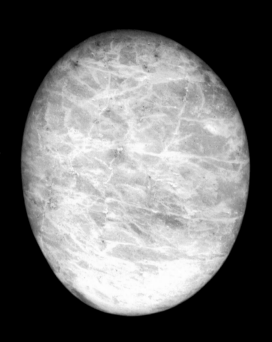

Watch Hill, Rhode Island

Tropical is among the last words that come to mind to describe Scotland, a land of low mountains, craggy coasts, and notoriously hard winters. However, the spaghetti-like colonies of *Lithostrotion* coral in this 250-million-year-old limestone (shown from two sides) attest to a time when the Earth was warmer and the region that would become Scotland was submerged in a shallow equatorial sea.

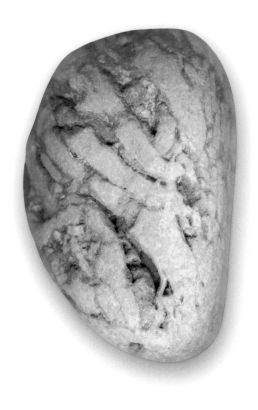

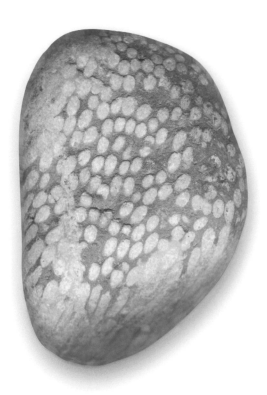

East Lothian, Scotland

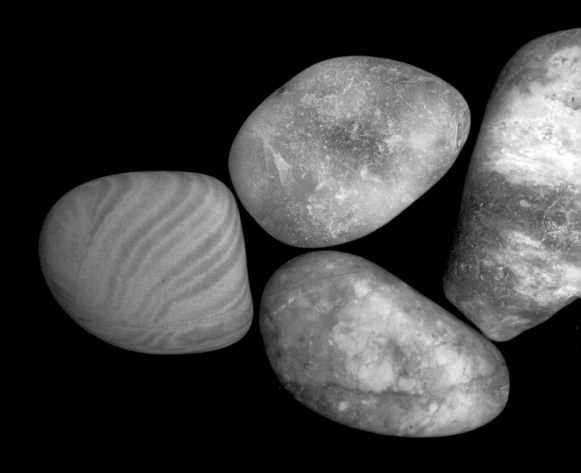

Gaspé Peninsula, Quebec, Canada

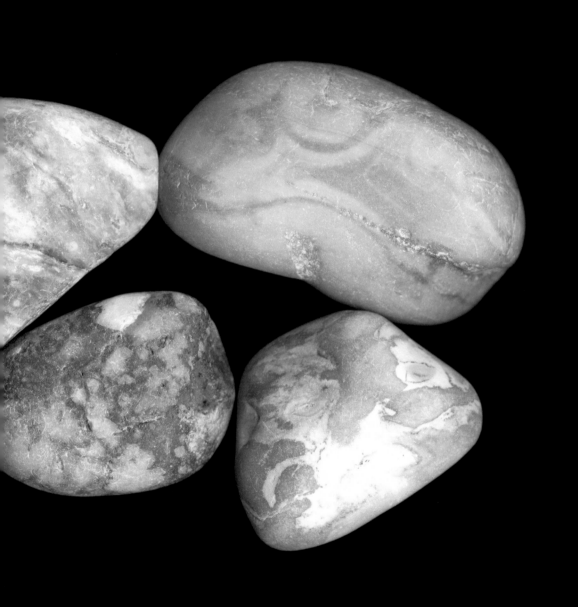

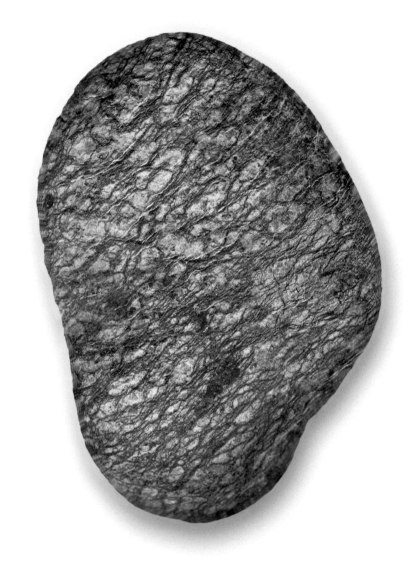

Troodos, Cyprus

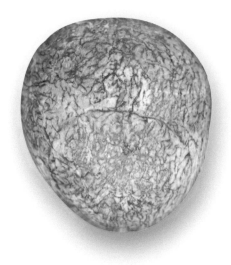

San Francisco, California

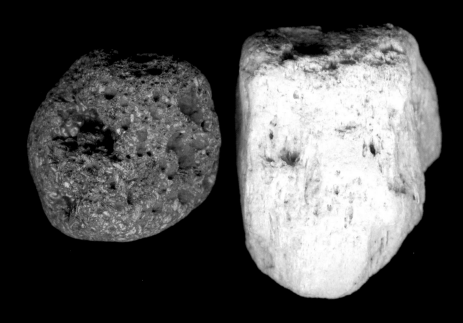

Stromboli, Italy

Few beach stones are collected so near to where they originate and so soon after they form as these basalt and pumice stones from the volcanic island of Stromboli. Gas-rich lava erupts into the air several times an hour, breaking into pieces and solidifying before raining down, much of it as small black basalt bombs with characteristic gas bubbles. Pumice, a fragile, light-colored combination of glass and air, results when the frothy lava solidifies too quickly for mineral crystals to form.

74

Tropical rainwater, seeping for millennia into the Ugandan soil and bedrock, dissolved iron from one site and deposited it in another, infusing these stones with the blood red of iron oxide minerals. What had been loose, fine soil has cemented in places into ironstone—a confirmation of the exasperated farmer's conviction that, given a bit of water, rocks, like plants, will grow.

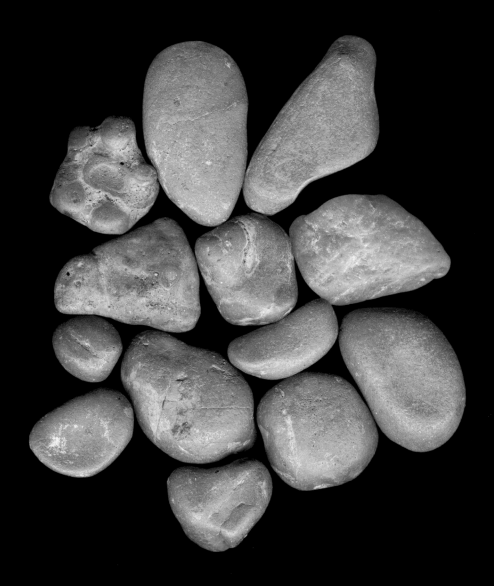

Jinja, Uganda

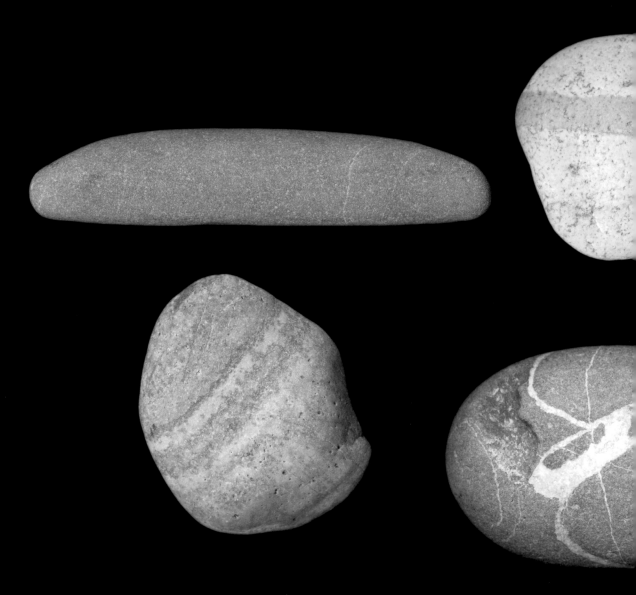

Guaymas, Mexico

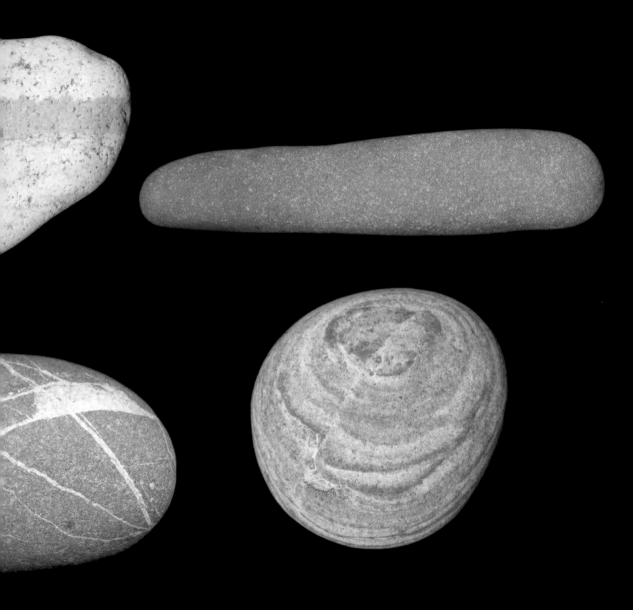

The various layers of this sedimentary sandstone have responded in slightly different ways to the elements over the years. The layers that stand out in relief are cemented by iron oxides, which endow the stone with greater resistance to wind, water, and the abrasion of other rocks.

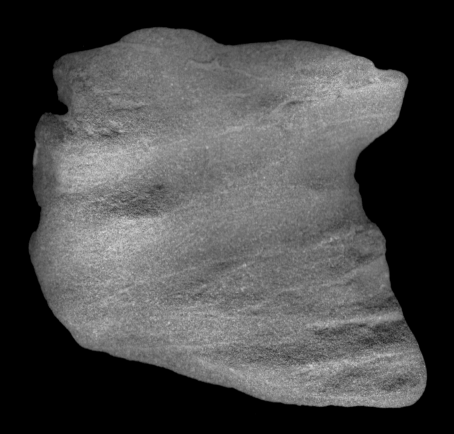

Whidbey Island, Washington

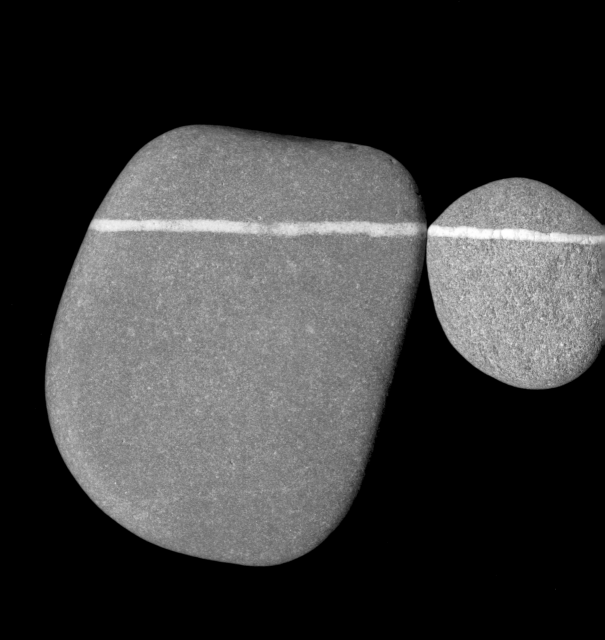

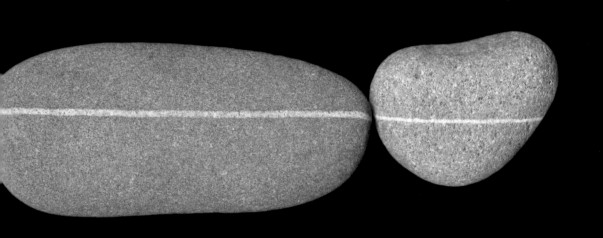

North Haven, Maine

Brimstone Island, Maine

In Maine's Penobscot Bay is a tiny island of shiny, smooth, dark black basaltic rocks known as brimstones. Smoothness is generally the result of a stone's journey from the bedrock from which it eroded to the beach where it was eventually laid down. The longer the journey, the more rounded the stone. This stone's particularly fine polish also arises from the microscopic size of its crystals and the homogeneity of the rock's composition.

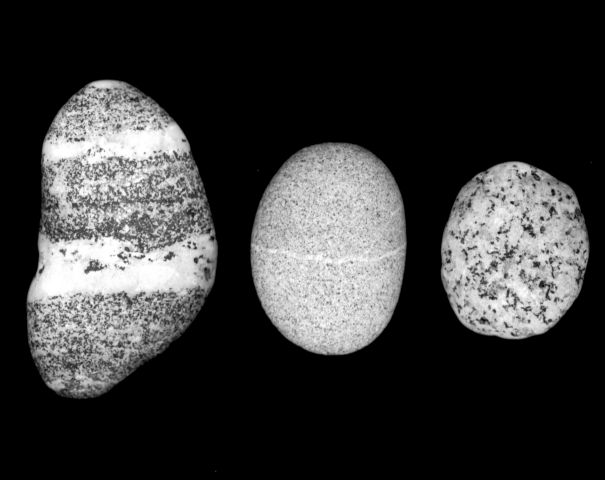

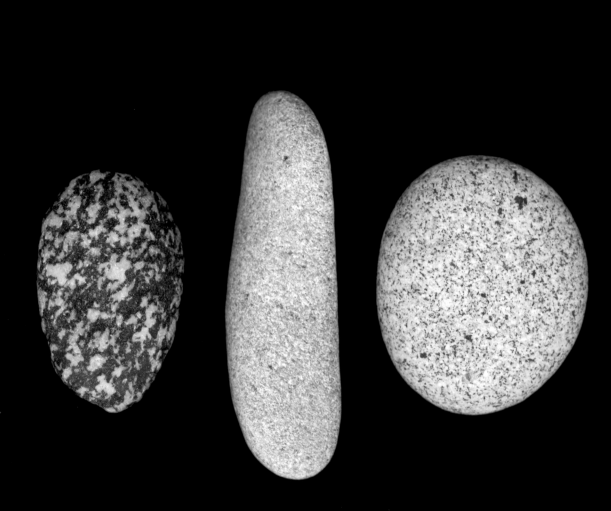

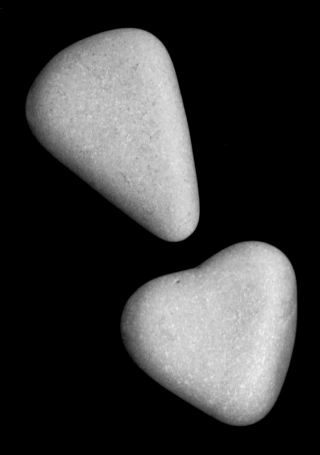

Grand Beach, Michigan

Michigan is covered almost entirely in loose sediment that was pushed and dragged by glacier from Canada. These pebbles, plucked up by the glacier, embedded in its ice, and scraped along the Michigan bedrock, likely helped excavate the bed of Lake Michigan and form Grand Beach along its southern shore.

Deep beneath the ocean floor, molten mantle migrates through pores and fractures in the crust toward the surface. Some of it erupts to form submarine mountain ranges, but much of it stalls in subterranean pools, where it cools slowly, allowing time for large, interlocking crystals to form, as in this gabbro, a type of granular igneous rock.

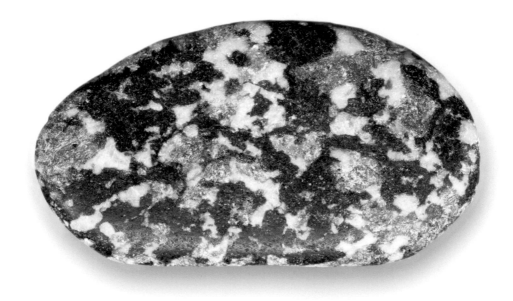

Governor's Beach, Cyprus

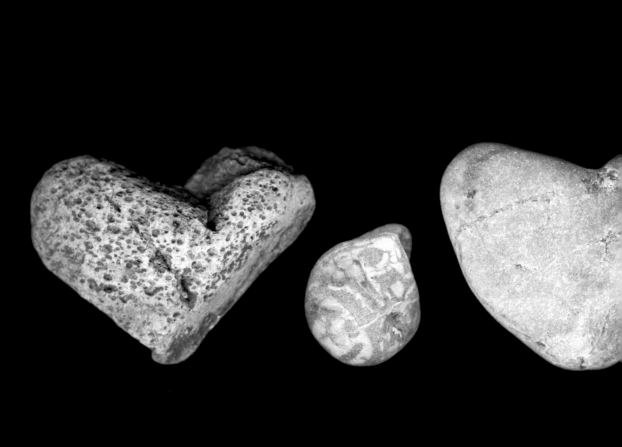

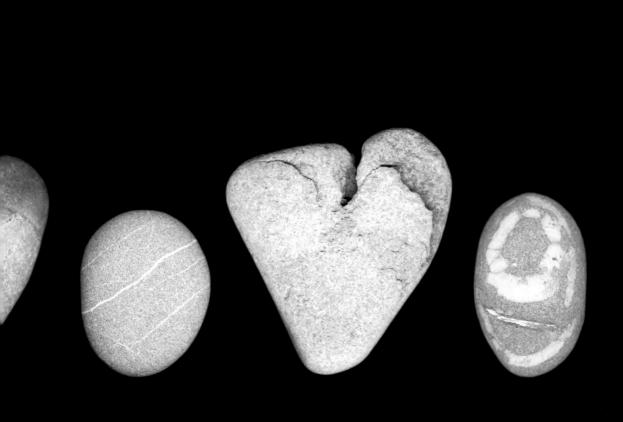

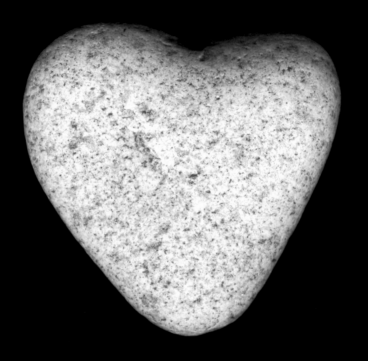

North Haven, Maine

The petrified valentines that can be found on many beaches were probably angular V-shaped rocks before arriving there. Years spent tumbling along streambeds and rolling in the surf rounded their edges and shaped them into soft hearts. A rock's unique shape arises from the weaknesses and variations within it: layers of soft mineral grains that crumble with abrasion; regions of chemically unstable minerals that dissolve easily in water; a crack through which water moves easily, carving the rock on either side; or the boundaries between layers, along which rocks tend to break.

Sand and grit, trapped in the small cracks and pits of a beach stone, can tumble and swirl with every wave. Tossed and knocking against weak spots in the rock, they may slowly drill a hole clear through to its other side. Here, one little pebble became wedged in the hole.

Lopez Island, Washington

Bolinas, California

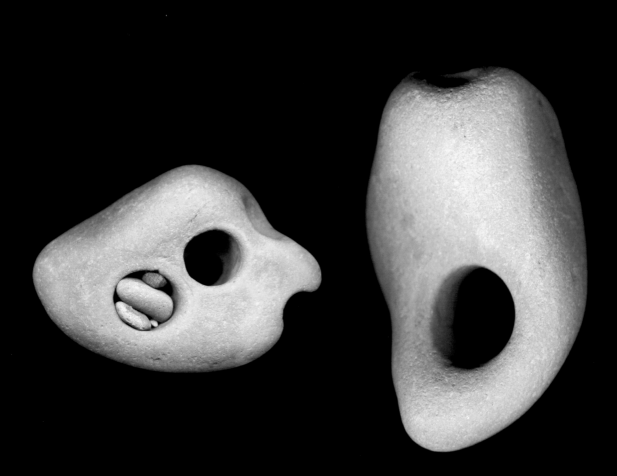

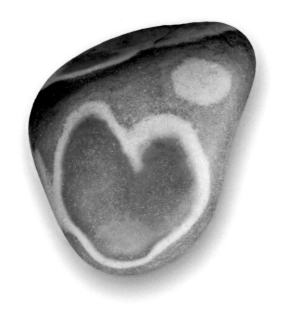

Playa Ocotal, Nicaragua

Beaches are some of the most dynamic places on Earth. Clusters of pebbles vanish overnight. The stone left to be picked up another day is nowhere to be found—perhaps buried, washed away, or simply rolled over. Or maybe its distinguishing feature—a heart, the remnant of a layer of ancient sediment— has eroded away, joining the sand at another beach.

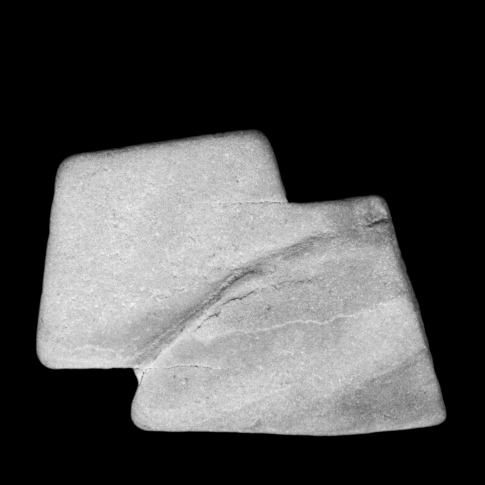

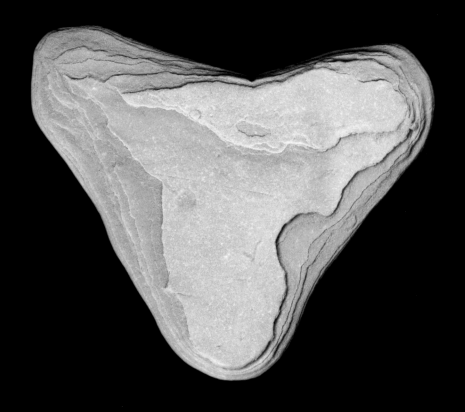

Grand Beach, Michigan

Some solid-colored stones are made of a single mineral. Others, like these from Scotland and the United States, are so finely grained that their various minerals' colors blend into one. Gray rocks may derive their color from iron- and magnesium-rich minerals or from the remains of plants and animals. Red, purple, and yellow rocks are colored with iron oxides, while green comes from iron minerals that formed in an oxygen-poor environment.

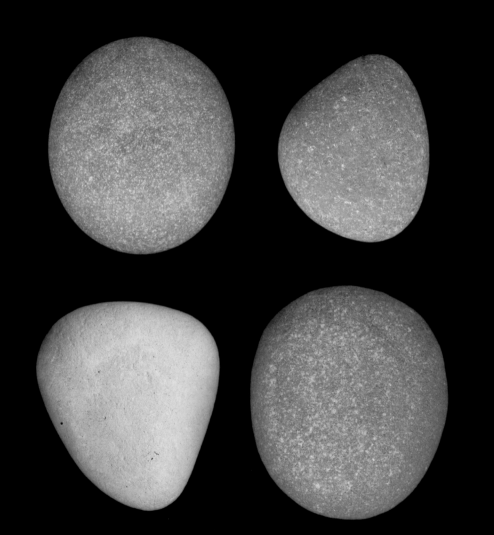

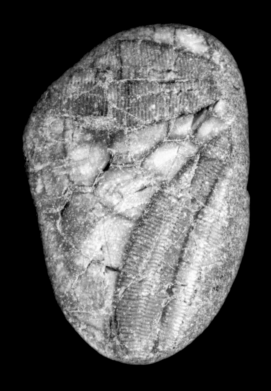

San Francisco, California

It is not uncommon to stumble upon a fossil while searching for stones along the beaches near San Francisco. This one is likely a fragment of a sand dollar's underbelly. When found within rock formations, fossils help us piece together the complex history of life on Earth. Even loose on the beach, divorced from their context, and therefore providing few hints of their age and origin, fossils afford an intriguing glimpse into the planet's past.

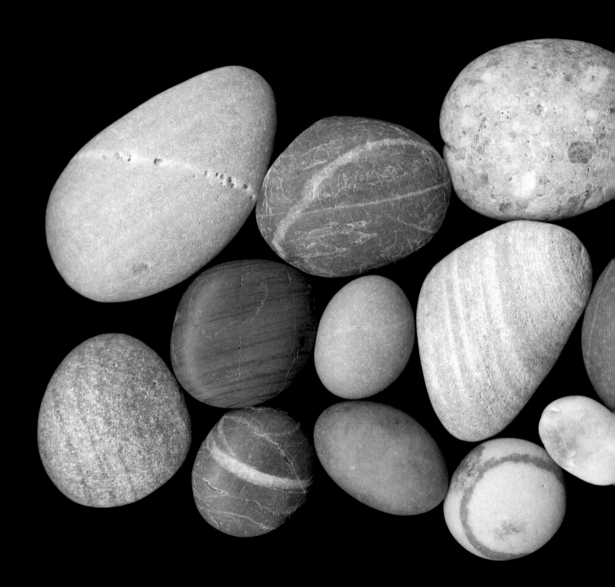

Devon, England

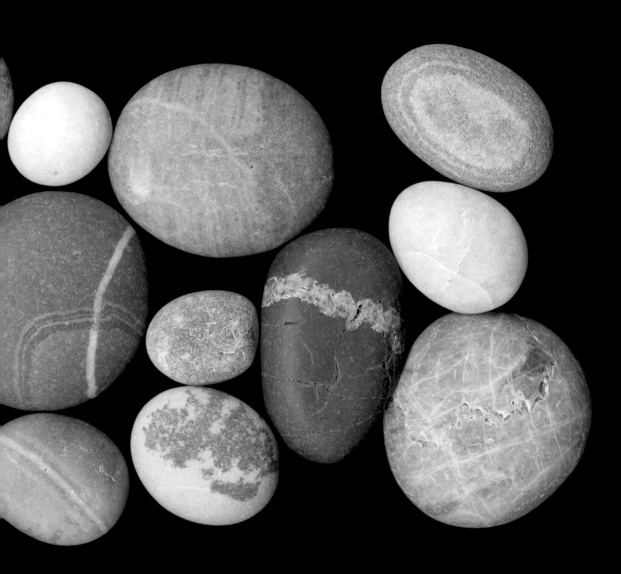

preceding pages: Many beach stones were once craggy rocks, their irregularities smoothed away after being tossed by waves and shoved against neighboring rocks for thousands of years. These pebbles from the southern coast of England began to be smoothed even earlier, during a period spent in the turbulence of a giant river that flowed there 230 million years ago.

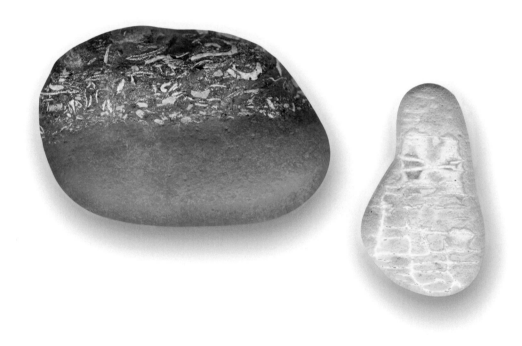

Grand Beach, Michigan

A fingerprint remains the same for a lifetime, even as layers of skin wear away and are replaced with new ones. Not so a stone's unique markings. Surface patterns will wear away or be modified by new weathering stains. And if the patterns reflect deeper structures—layers, as in this stone, or embedded crystals and fossils, faults and folds—they will change continuously, as slow abrasion reveals a slightly different view.

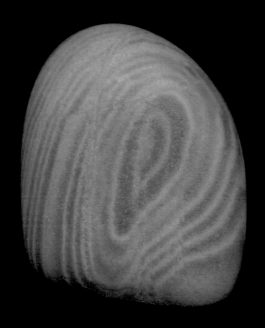

Gaspé Peninsula, Quebec, Canada

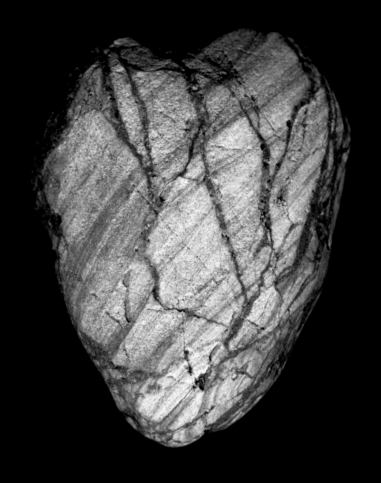

Devon, England

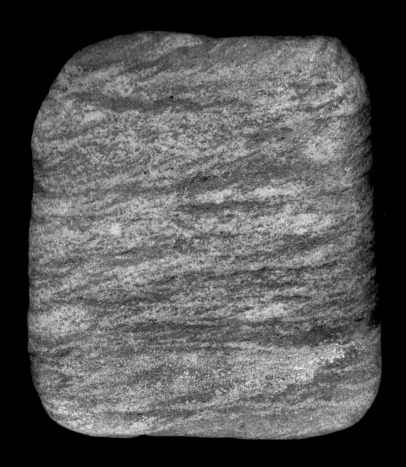

Fife, Scotland

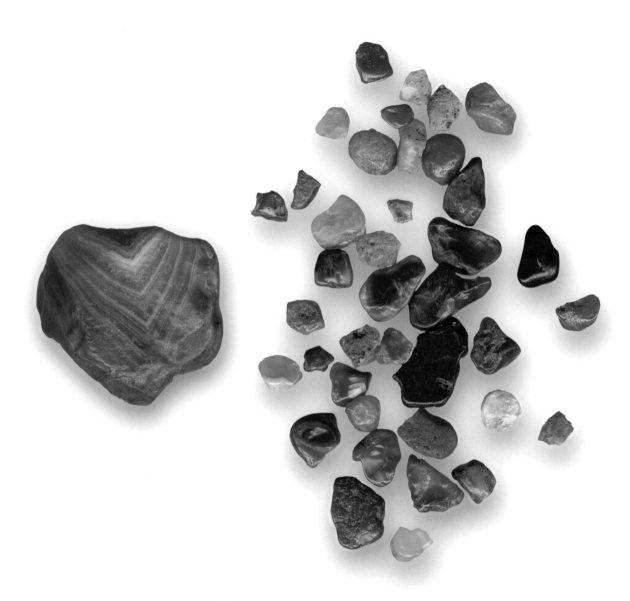

Gooseberry Falls State Park, Minnesota

The Gooseberry River cascades over seven lava flows as it makes its way to Lake Superior, gathering agates like these as it scours the billion-year-old rocks that make up its bed. Slowing abruptly when it reaches the lake and no longer able to carry its load, the water deposits the agates in sand bars. Agate is a variety of quartz colored by other minerals, such as hematite, and elements such as iron.

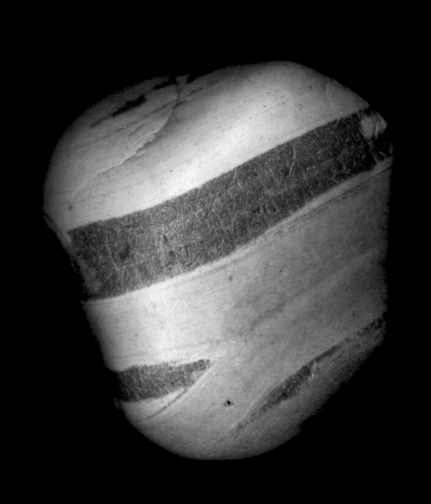

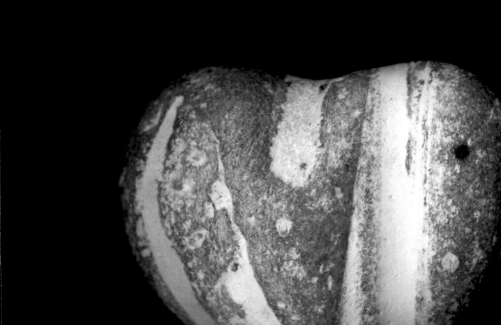

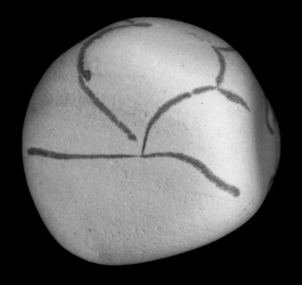

Playa Ocotal, Nicaragua

The calligraphic strokes on this smooth, fine-grained sandstone were brushed in iron oxides drawn from water penetrating hairline cracks in the stone.

119

The smooth yet irregular shape of this pink gypsum, or alabaster, derives from both its chemical composition and its recent residence along the Bristol Channel. Gypsum, like salt, forms when seawater evaporates, leaving once-dissolved minerals behind as rock. A rock drawn from the sea can also be consumed by the sea, as waves and rainwater unevenly dissolve it over time.

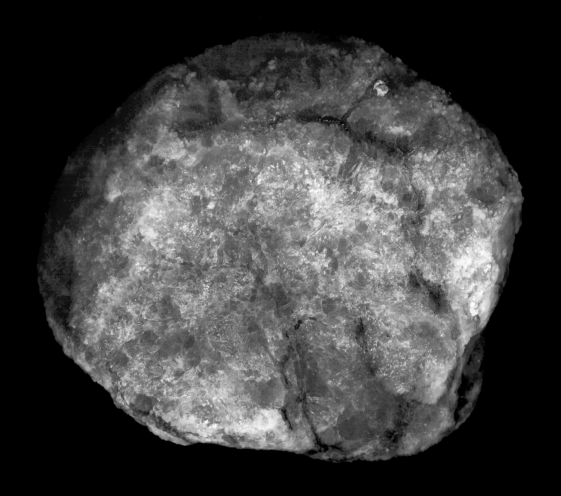

Somerset, England

The river of quartz that meanders through these sedimentary rocks was formed by the same forces involved in the creation of the North American continent: tremendous heat and pressure applied over a vast amount of time. The vein on the left, threading through a sandstone that was deposited off the Atlantic coast, was crumpled with the sediments between the tectonic plates when the Appalachian Mountains were forming some 400 million years ago. The vein on the right cuts through a mass of recrystallized skeletons of tiny marine creatures, which was folded as it was thrust from the Pacific onto the California coast 150 million years ago.

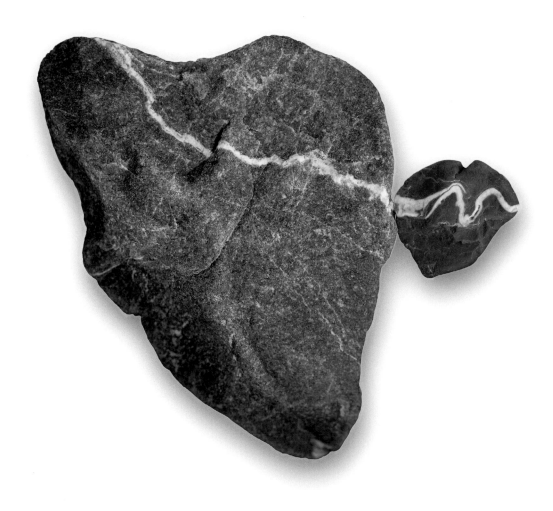

Vinalhaven, Maine | Point Reyes, California

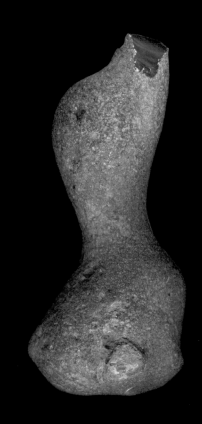

Fynn, Denmark

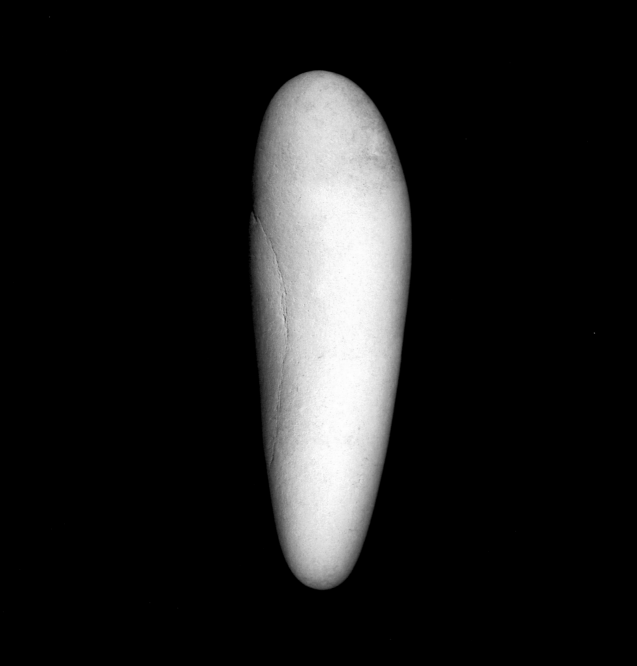

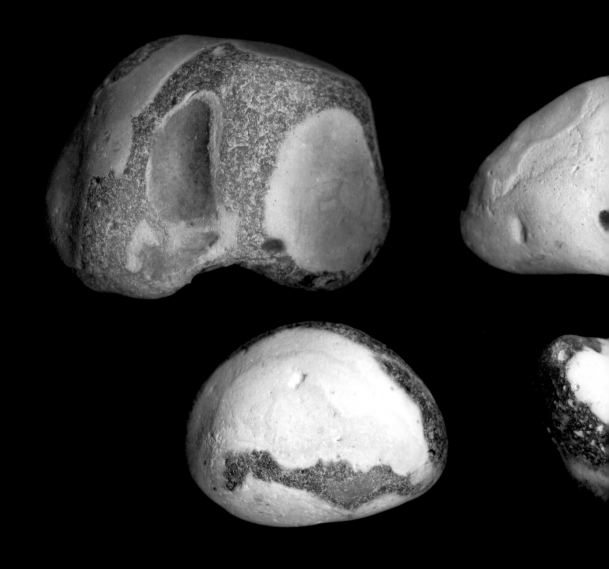

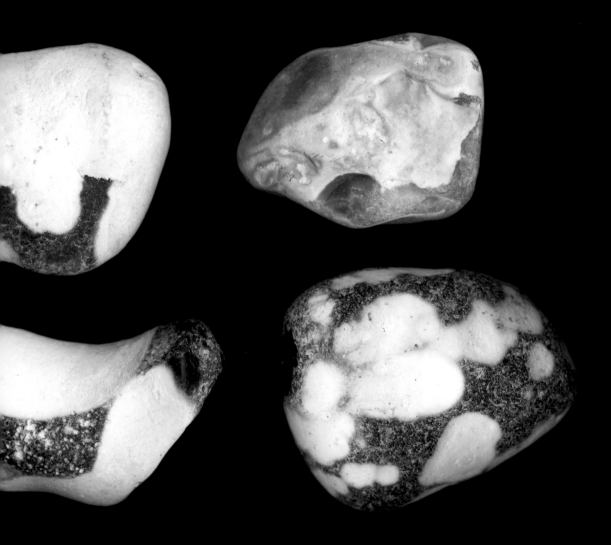

East Sussex, England

128

preceding four pages: Along the base of the white chalk cliffs of western Europe run banks of hard, smooth pebbles in black, gray, brown, and white. They are flints, nodules of finely crystallized quartz that have eroded from the soft chalk (which still partly coats the six grouped flints). Both the flint and the chalk originated about ninety million years ago in the sea that covered the area. The scales of dead algae covered the seabed, forming the lime mud that eventually became chalk, while dissolved sea sponge spines turned into a gel that filled the labyrinthine burrows some unknown sea creature had made in the mud, and ultimately solidified into flint. Many flints have been broken and rounded, but others, like the "duck" here, retain an irregular shape.

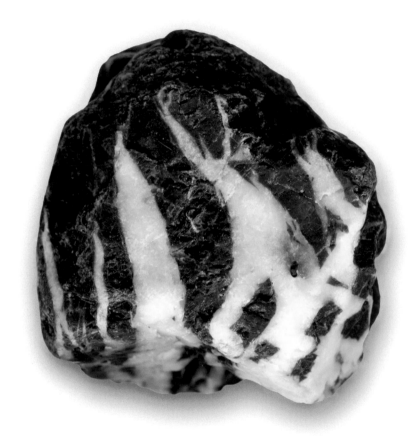

Stinson Beach, California

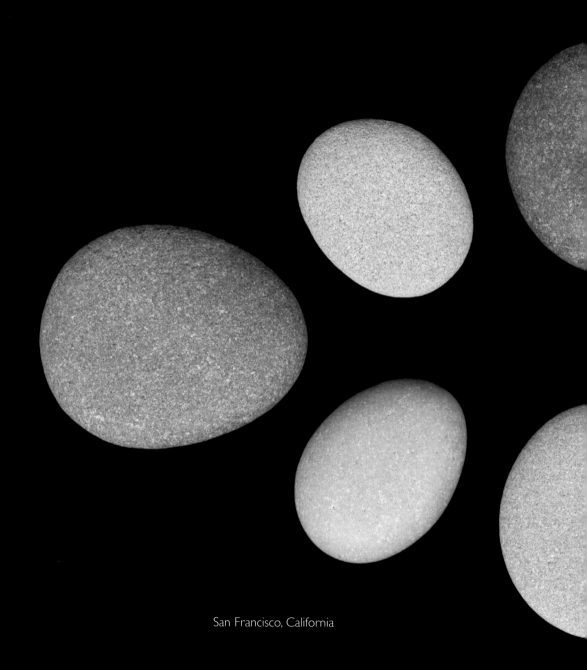

San Francisco, California

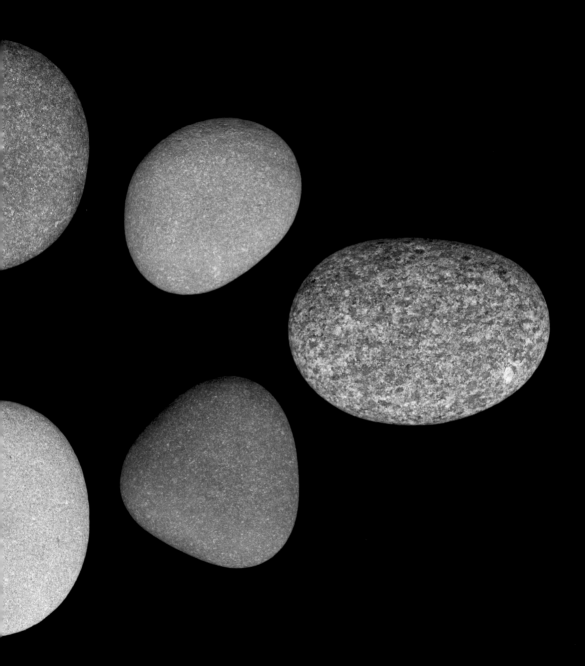

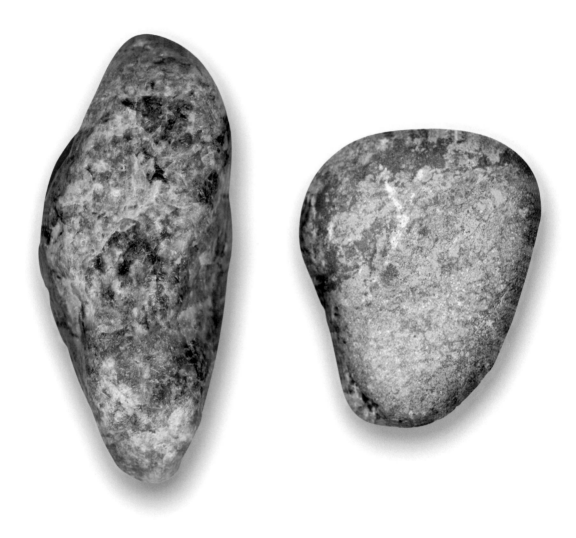

Ilimaussaq, Greenland | San Francisco, California

The pebble on the far left originated more than a billion years ago and several miles beneath the Earth's surface in a body of magma that pierced the ancient rocks that now make up Greenland. As water, wind, ice, and gravity wore away the overlying rocks, the frozen magma slowly rose toward the surface. The serene beauty of its large pink crystals belies the stone's turbulent past.

It was not waves, tides, or ocean currents that brought these limestone pebbles from the floor of the tropical sea where they formed more than 600 million years ago to the chilly west coast of Scotland; it was currents in the nearly solid rock deep beneath the Earth's surface. The massive slabs of brittle rock that make up the continents and ocean floors are in slow but continuous motion.

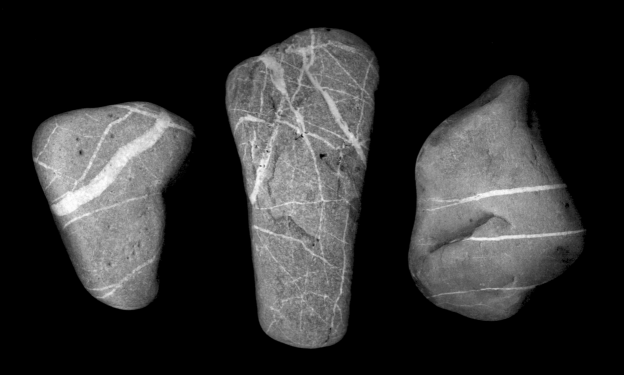

Lismore, Scotland

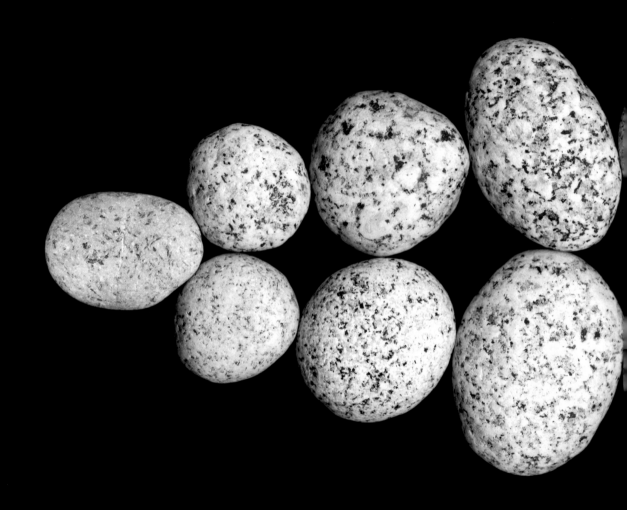

Isle au Haut, Maine

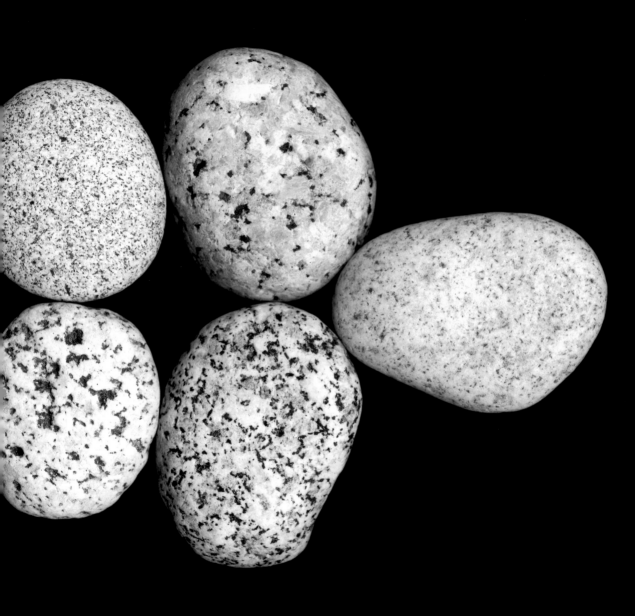

artist's note

Like many people, I have always collected stones. They are so satisfying—
so ubiquitous, so varied, so abundant, so comforting to hold or to find lying
around the house. Whether on the rocky coast of Maine or a sandy beach in
California, I cannot help but fill my pockets. Wandering near the water's edge
and picking up whatever catches my eye is the greatest antidote to daily stress
I know. Whether it's a lucky stone with a ring around it, a perfect egg, or a
heart-shaped rock, the joy in the finding is simple and profound: treasure.

This book presents more than two hundred stones from beaches around
the world. Many of the stones here are my own and the writer's, but others
have been shared by friends far and wide. It is by no means a definitive
collection. The beauty of beach stones is that there *is* no definitive collection;
there are always more-fantastic specimens to gather from the shore.

As photographer, I get to *really* look at the stones whose images I
capture, watching as the individual pebbles reveal, in nuanced detail, their
unique physical presence. I fall in love with each one. I feel privileged to listen
as the stones quietly speak of where they come from and the world they
inhabit. The stones themselves dictate what shapes the images should take,
what sequences they should follow. The designs that emerge are a language
of sorts, hieroglyphs of pure form.

About ten years ago, the urge to place objects directly on my flatbed scanner resulted in my near abandonment of the actual camera. I scanned everything around me: shoes, toast, dryer lint, watermelon, and, of course, stones. The technique allowed me the spontaneity to examine those objects with a depth and level of detail I couldn't achieve with the camera. I was hooked and now generate images exclusively with my scanner.

Choosing a stone is a mark-making act, a small bit of artistry in collaboration with nature. I must thank all the artists who shared their stones for this project: John Rafkin and his three children, Cathy and Ben Iselin, Margot Herrera, Jori Hook, Linda Davidson, Joanne Dames, Lisa Gross, Jim and Kate Stickley, Susan Scheer, Alison Porter, Dick Graybill, Caroline Herter, Carolyn Rebbert, Bill Minark, Tony and Michelle Roderick, Steve Shaver, Brian Upton, Steve and Beverly Howells, and Richard Ash.

As I wrapped and unwrapped their stones, worried sick I might lose a tiny pebble, I realized that these stones, although of no monetary value, are as precious as family heirlooms. They are the chosen ones, destined to sit in clusters on the mantel or in a jar over the sink and to be held every once in a while for a closer listen to their whispered revelations.

JLI

author's note

The history of a rock is written in its shape, texture, and composition, but both the writing and the language are obscure. As in an ancient palimpsest, each chapter in the history has been scraped off, fragmented, and overwritten by the next. Simply identifying a rock can be challenging, and beach stones are notoriously difficult. The smoothness that makes a stone so appealing conceals the texture of the rock and the true color of its mineral grains. And because beach stones might have traveled hundreds of miles from their sources, their origin, age, and significance can be difficult, if not impossible, to establish without the help of expensive analytical equipment and weeks of field and lab work.

Some of the stones pictured in this book yielded their stories simply, through photographs, while others required more direct observation, from all sides and under a microscope. Information about some of the stones relied on the work of geologists who have examined the bedrock from which they originated. Our understanding of the origin and evolution of these rocks derives from the investigations carried out by thousands of geologists over the past 250 years.

This book certainly does not begin to answer all the questions that can be asked about beach stones. My hope is that the little bit of information

here will be satisfying to some, and that the holes are just big enough to allow curiosity to seep in.

 Special thanks to Eric Himmel and Josie Iselin, whose insightful questions and observations about beach stones guided the text. Thanks also to my editor, Nancy Cohen, and many Earth scientists, including Steve Shaver, Carolyn Rebbert, Bill Minarik, Brian Upton, Tom Anderson, Matthew James, Alcina Barreto, and Richard Ash, for their invaluable input.

MWC

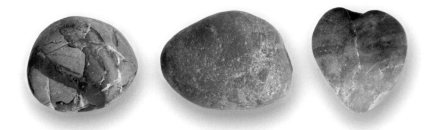

glossary

bedrock the solid, consolidated rock exposed or lying beneath soil at the Earth's surface

crust the Earth's outermost solid layer; the continental crust includes the rocks of the continents, while the oceanic crust underlies the ocean

igneous rock a rock that forms when molten rock solidifies

magma molten rock beneath the Earth's surface; lava is molten rock above the Earth's surface

mantle the layer of hot, mostly solid rock between Earth's crust and core

metamorphic rock a rock that heat or pressure has transformed from a different rock

sedimentary rock a rock that forms when pieces of other rocks cement together naturally, or when dissolved minerals crystallize out of water

tectonic collision the convergence of two tectonic plates, which ultimately results in mountain formation

tectonic plates massive slabs of Earth's crust and uppermost mantle that are in slow but continuous motion—colliding, moving apart, and grinding past each other over Earth's surface

volcanic rock an igneous rock that solidifies on the Earth's surface, rather than underground